SuperVisions

IMPOSSIBLE OPTICAL ILLUSIONS

Al Seckel

Sterling Publishing Co., Inc.
New York

Art/Photo credits, courtesy and copyright 2005 the artist:
pp. 9, 14, 26, 28, 34, 40, 43, 57, 68, 82 — Sandro Del-Prete
pp. 10, 12, 45, 61, 69, 80, 92 — Jos De Mey
p. 16 — Bruno Ernst
pp. 11, 28, 35, 55, 62, 79, 81, 90 — Tamas Farkas
pp. 59, 93 — Shigeo Fukuda
pp. 7, 29 — David MacDonald

pp. 32, 76, 88, 91 — Guido Moretti
pp. 46, 60 — Scot Morris
pp. 30, 66, 67, 74, 84 — István Orosz
pp. 19, 24, 25, 41, 47, 48, 49, 54, 56, 57, 64, 65, 71, 72, 73, 86, 89, 94 — Oscar Reutersvärd
pp. 5, 6 — Roger Shepard

Book Design: Lucy Wilner
Editor: Rodman Pilgrim Neumann

Library of Congress Cataloging-in-Publication Data
Seckel, Al.
 Super visions : impossible optical illusions / Al Seckel.
 p. cm.
 Includes index.
 ISBN 1-4027-1830-6
 1. Optical illusions. I. Title.
QP495.S437 2005
152.14'8--dc22

2005002255

2 4 6 8 10 9 7 5 3 1

Published by Sterling Publishing Co., Inc.
387 Park Avenue South, New York, NY 10016
© 2005 by Al Seckel
Distributed in Canada by Sterling Publishing
c/o Canadian Manda Group, 165 Dufferin Street
Toronto, Ontario, Canada M6K 3H6
Distributed in Great Britain and Europe by Chris Lloyd at Orca Book
Services, Stanley House, Fleets Lane, Poole BH15 3AJ, England
Distributed in Australia by Capricorn Link (Australia) Pty. Ltd.
P.O. Box 704, Windsor, NSW 2756, Australia

Sterling ISBN 1-4027-1830-6

For information about custom editions, special sales, premium and
corporate purchases, please contact Sterling Special Sales
Department at 800-805-5489 or specialsales@sterlingpub.com.

CONTENTS

INTRODUCTION

Inside this book you will find the largest collection of impossible figures ever assembled, not only some familiar classics, but also many new and previously unpublished drawings. Although impossible figures suggest real physical objects, they can't possibly exist. Physical objects cannot be constructed in these paradoxical ways. Nevertheless, your mind tells you that they can exist, at least on paper!

So, what is going on? Your brain is used to interpreting perspective drawings in a certain way. As you examine the figures, you will see the paradoxes, but you can't stop seeing them in your mind's eye as three-dimensional objects. Your conceptual knowledge will not override the constraints of your visual system in how it interprets perspective drawings, even when the objects are impossible, inconsistent, or paradoxical.

Inside this volume, you will also see a variety of physical objects, which also appear impossible, but there they are! Some people have used clever optical tricks to build physical objects that appear to be impossible. Yet, these objects are impossible from only one properly controlled viewing angle. Any other vantage point will destroy the illusion and reveal their true construction.

Although in some sense, all the illusions in this book are puzzlers, they are not an intelligence test. Some paradoxes you will see right away, and others will be a little more difficult. Yet, they are all meant to be fun!

—Al Seckel

L'Egistential Elephant

Impossible Elephant Stable

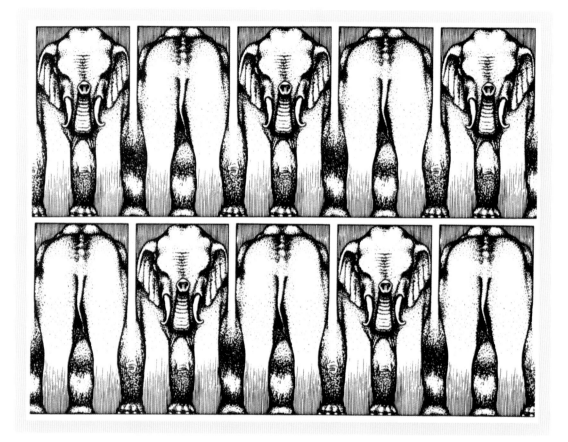

This is what you would see if you saw a stable of impossible elephants.

The Impossible Terrace

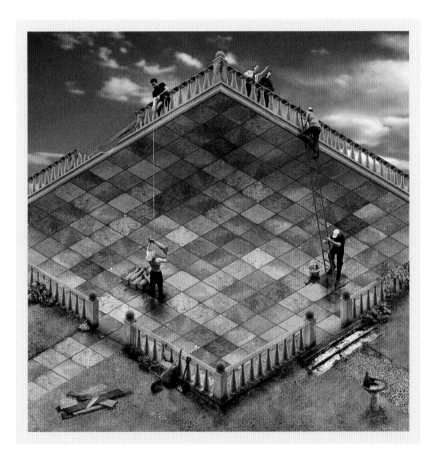

Are you seeing this balcony from above or below?
Also, the ladder seems to twist in a strange way.

An Impossible Staircase

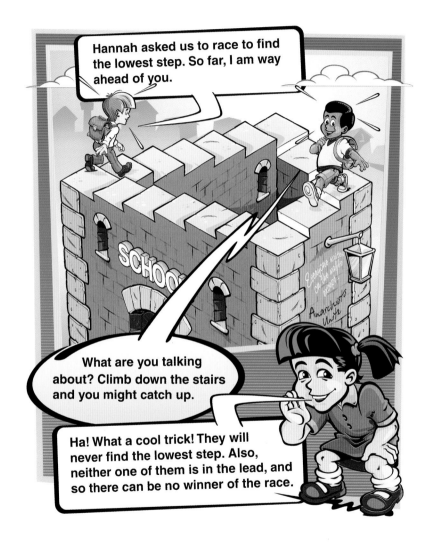

Window Gazing

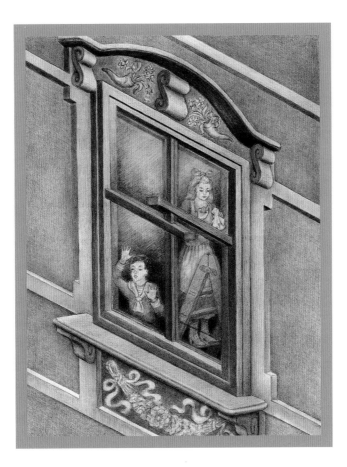

*In this strange window, you can look out in two
different directions simultaneously.*

Melancholy Tunes on a Flemish Winter's Day

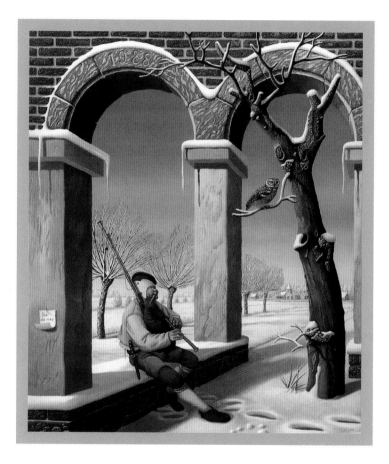

How does the left column come forward?

An Impossible Configuration

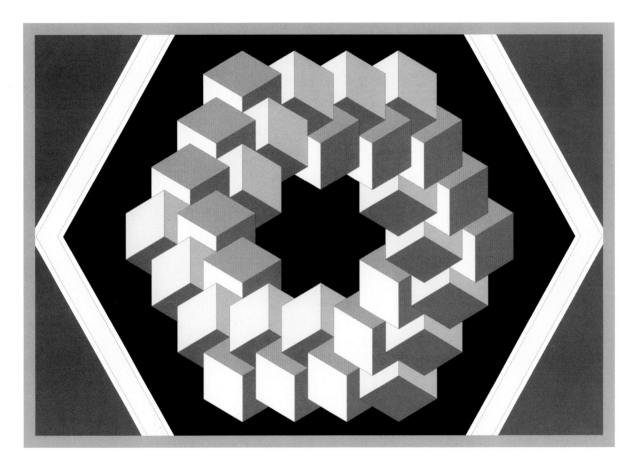

Is this configuration of cubes possible?

A Birdcage of the Fourth Dimension

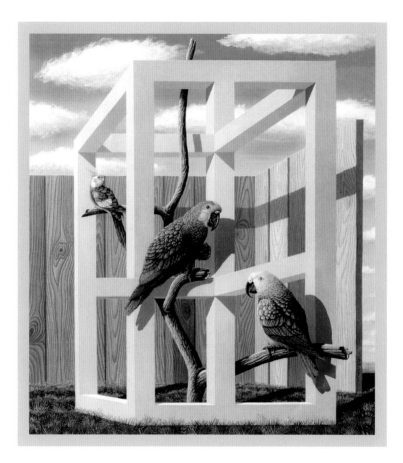

There is something peculiar about this birdcage.

The Thiery Figure

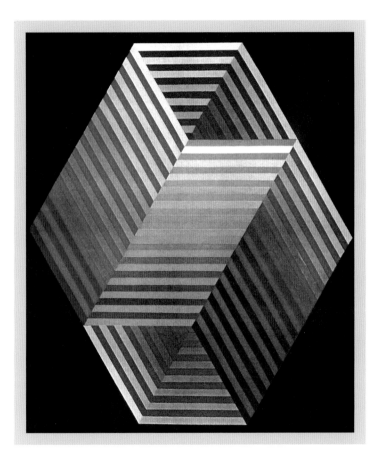

This figure will flip-flop when you stare at it, and the middle side will be either above or below.

Between Illusion and Reality

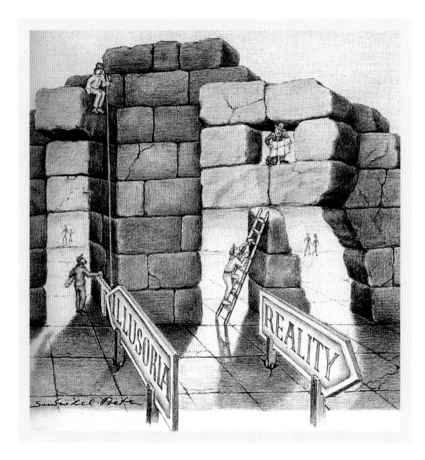

The top section appears to be solid and the bottom section appears to be a passageway. Cover either the top or bottom part.

Shadow Play

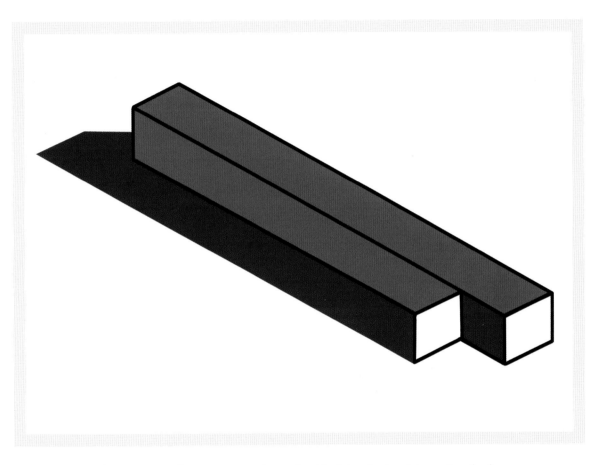

There is something strange about the block's relationship to its shadow.

Reflections of an Impossible Triangle

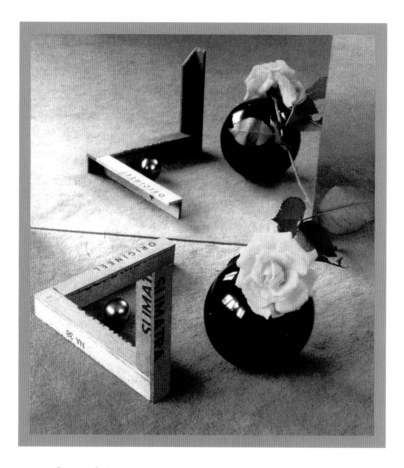

In front of the mirror you can see an impossible triangle.
The reflection reveals how it is made.

Nob's Impossible Ledge

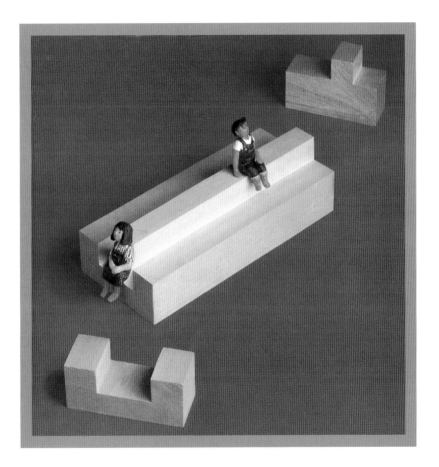

The little male figure on the right sits on top of a ledge, but if you follow the ledge to the left, the female figure sits in an indentation.

The Impossible Fork

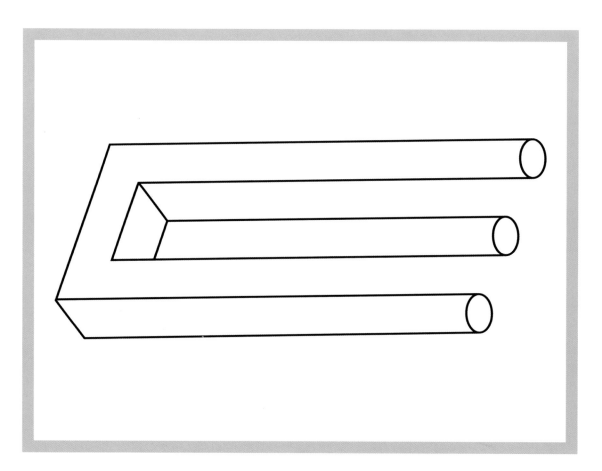

What is wrong with this figure? How many prongs can you count? What happens to the depth of the middle prong? Cover either side of the figure, and each side will appear perfectly possible, but when you uncover the two sides, it appears impossible again.

Impossible Meander

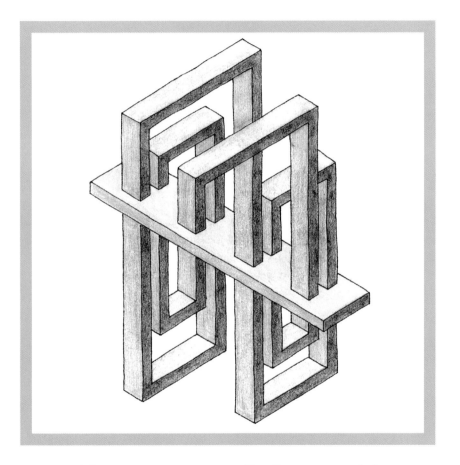

This construction is impossible. Can you see why?

Hogarth's Mistakes of Perspective

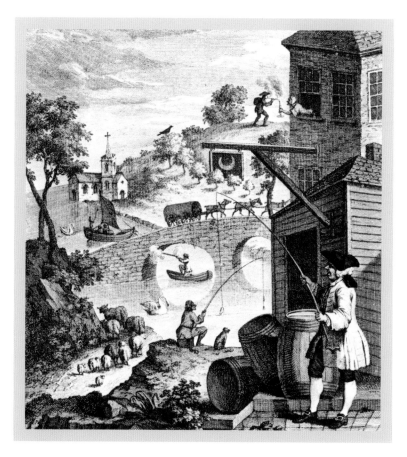

How many perspective mistakes can you find in this picture?

A Mesh of Gears

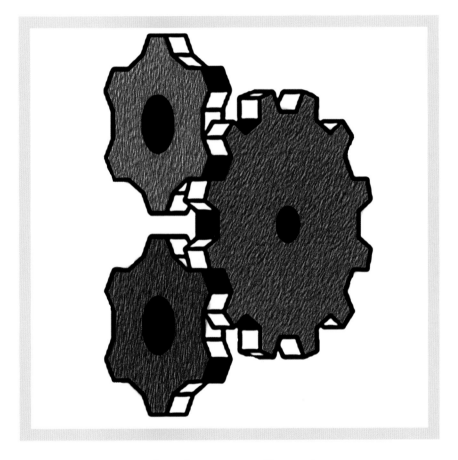

Can these gears really turn?

An Impossible Shelf

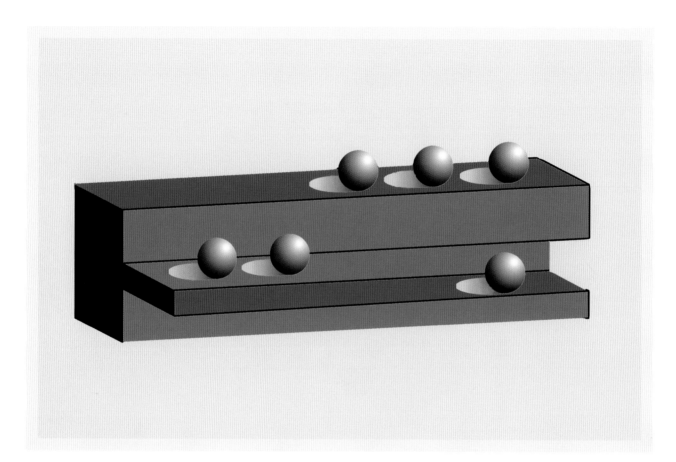

What is wrong with this shelf?

Solids Passing through Solids

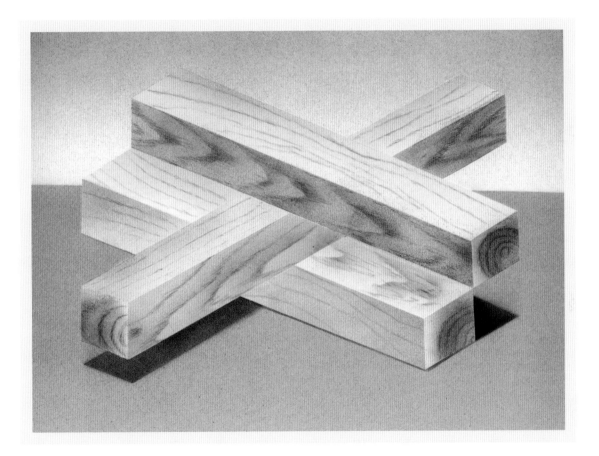

How can a solid block of wood pass through the other two blocks in this way?

Level, but Rising

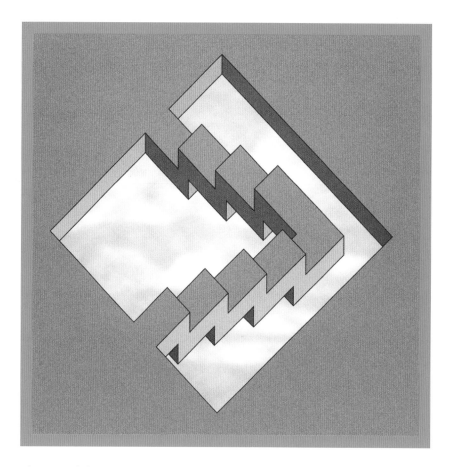

Each step of this staircase is level with each other step, which is impossible.

An Impossible Triangle with a Strange Twist

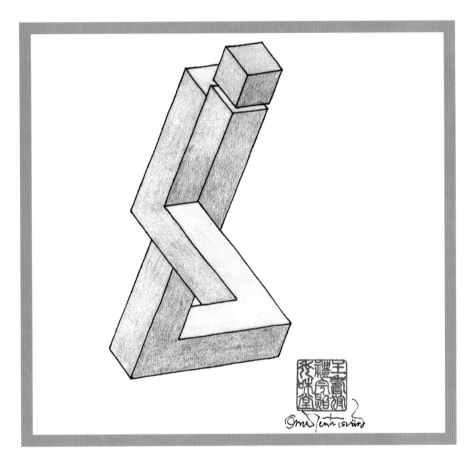

Notice how the figure connects with itself.

Incident on a Railway Bridge

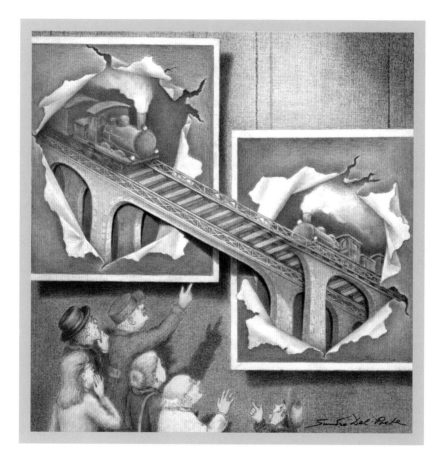

Are these trains going to collide?

An Impossible Meander

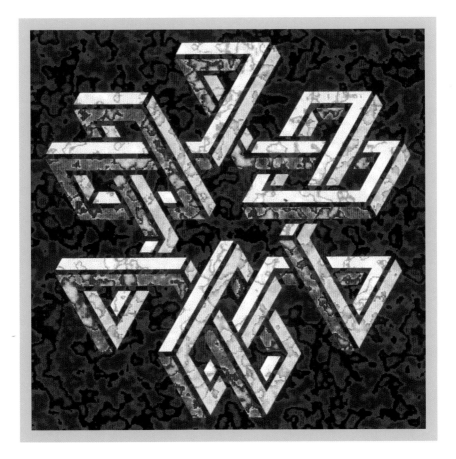

This meander is impossible.

Cosmic Wheels

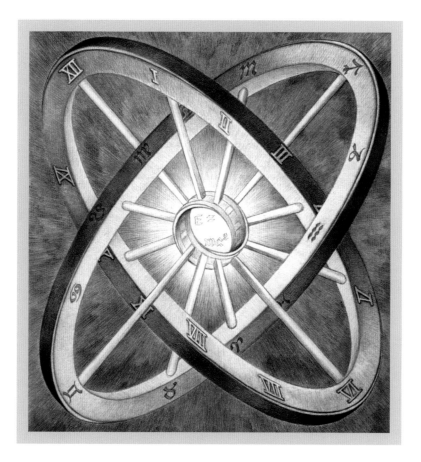

The three rings twist in an impossible way.

Perigrinations

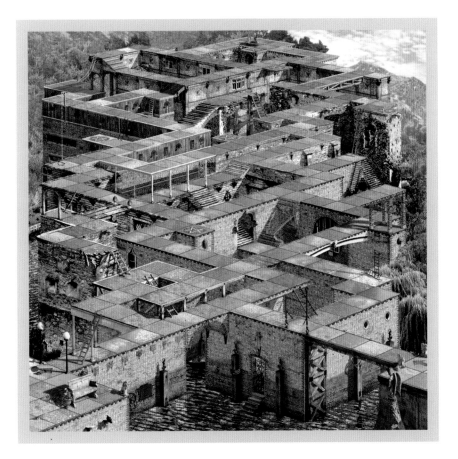

There are a lot of impossible stairways here.

Pergola

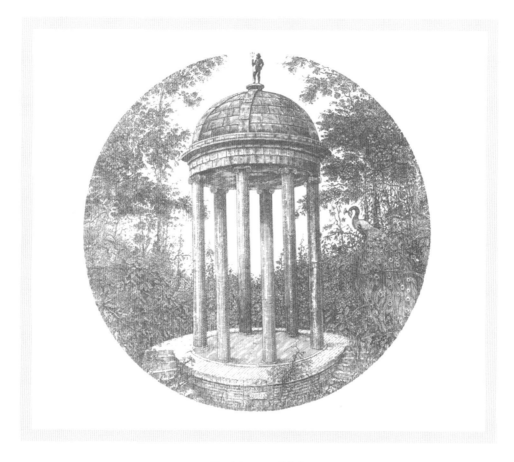

Is this possible?

Not a Knot

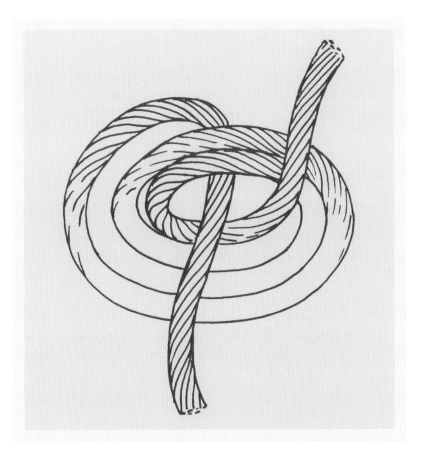

This knot may not be possible.

Moretti's Impossible Blocks

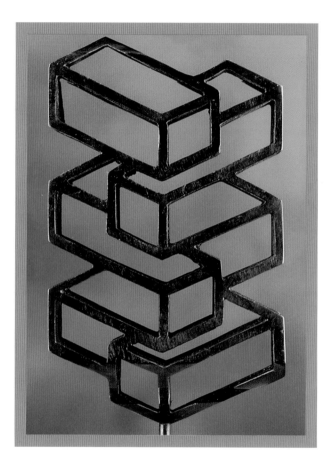

This sculpture has impossible blocks.

Penrose's Strange Stairway

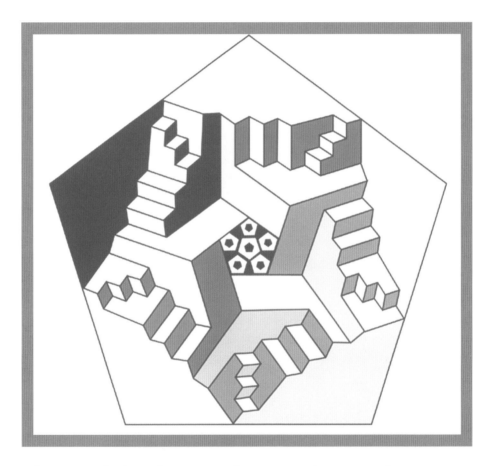

If you start climbing this staircase from a vertical position, when you arrive back at the starting point, you will arrive in a horizontal position.

Soldier of the Lattice Fence

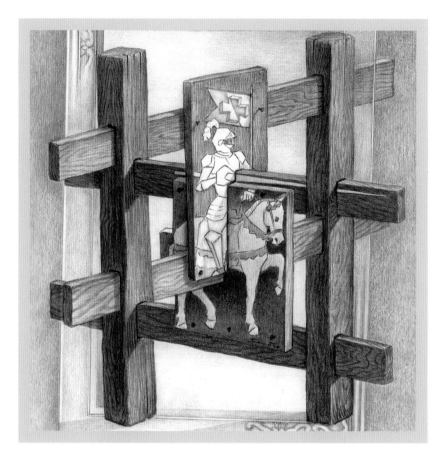

Can you connect these beams in this fashion.

Sidewinder

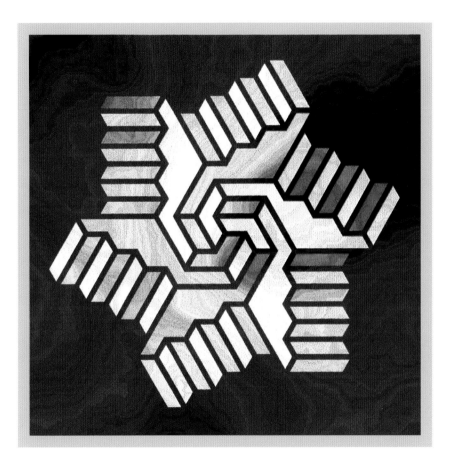

The orientation of this impossible staircase will flip-flop.

Which Way?

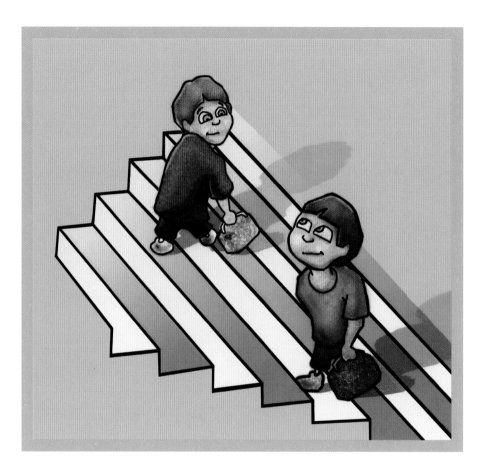

Are these stairs possible?

The Impossible Triangle

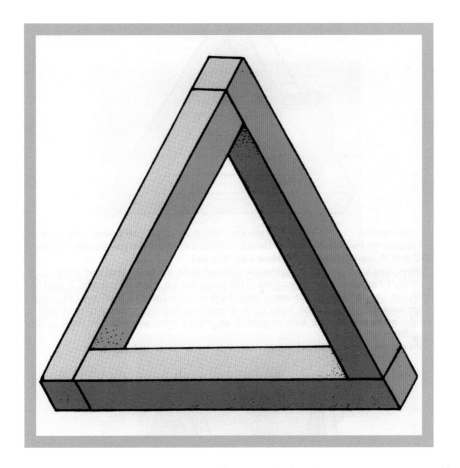

This is probably the most famous impossible figure, which is known as an impossible triangle. The arms simultaneously go away from you and toward you, yet they somehow meet. Separately cover each corner of the triangle, and see how differently your mind interprets this figure

Turner's Blocks

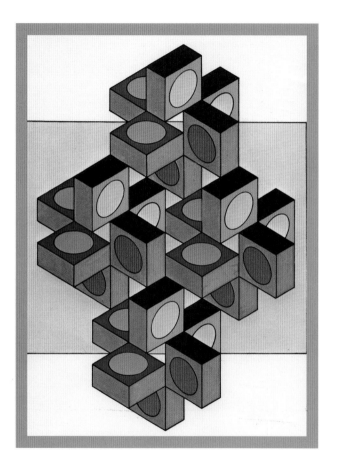

Can you arrange physical blocks like this?

Squaring the Circle

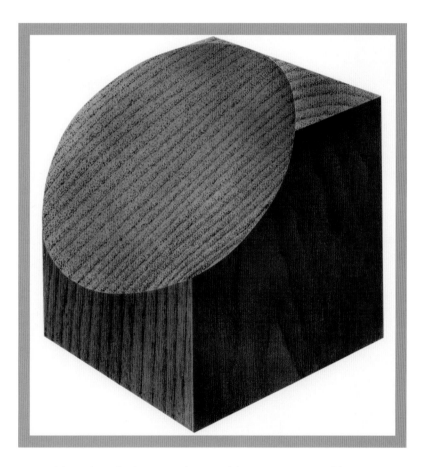

Although it looks entirely possible, it is not possible to cut a block in this fashion.

The Impossible Love of Romeo and Juliet

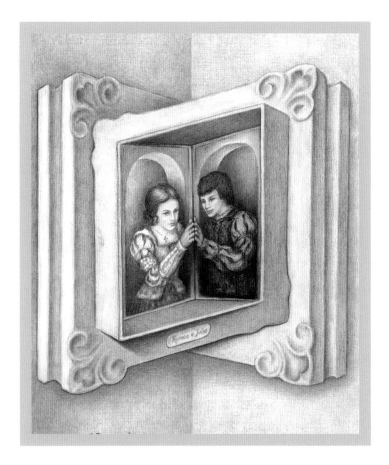

The two lovers Romeo and Juliet are connected in an impossible way.

Reutersvärd's Strange Paradox

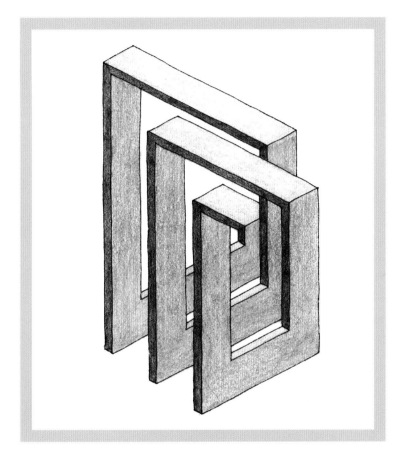

Can you find what is impossible here?

Anno's Puzzle

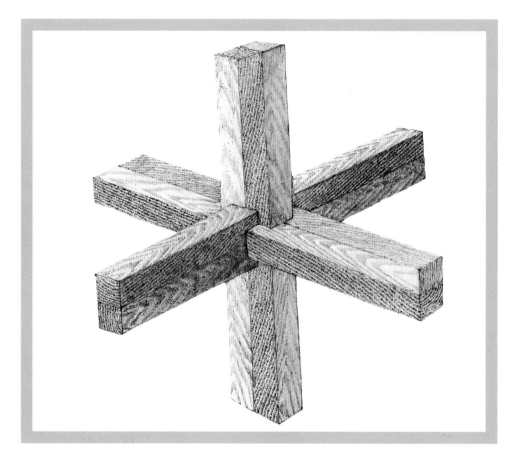

Some of the sides of this wooden block puzzle twist in a strange way.

The Astronomical Clock

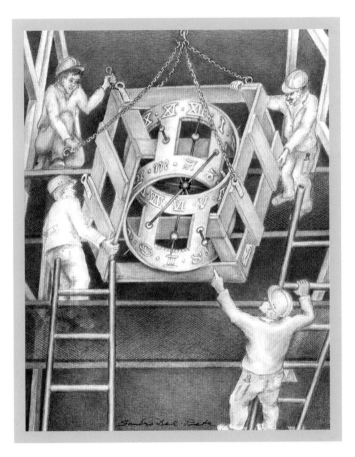

Can you find all the impossibilities here?

Contradiction in Terms

Contemplating the Fourth Dimension in a Strange Window

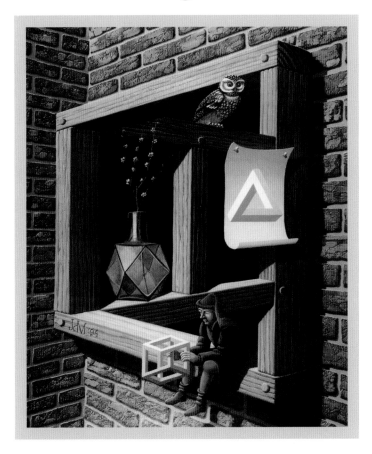

The sitting man in an impossible window thinks about an impossible cube.

Andrus's Box Impossible

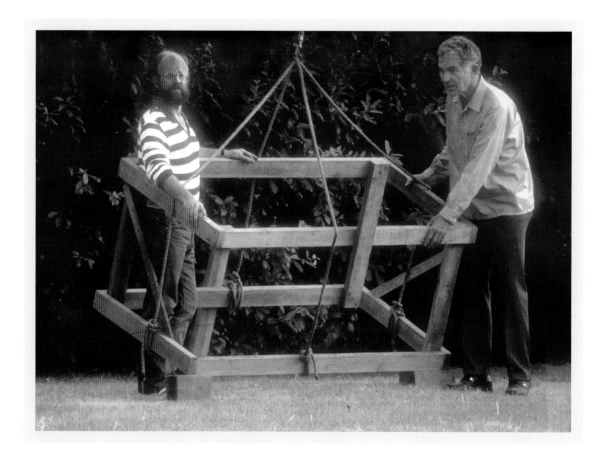

This is crate is impossible. The back beams seem to go in front of the front beams and then connect to the back beams. Try to think how this was constructed, and then see the solution on page 60.

Reutersvärd's Impossible Window

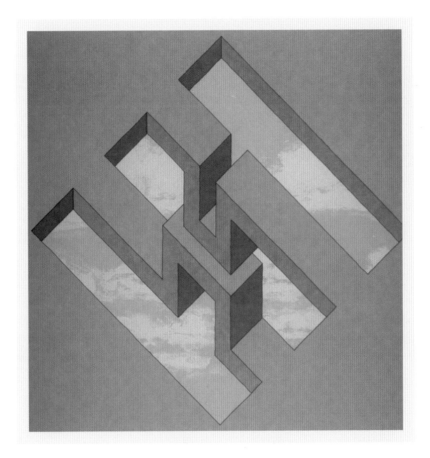

How could this possibly be?

Too Many Paradoxes

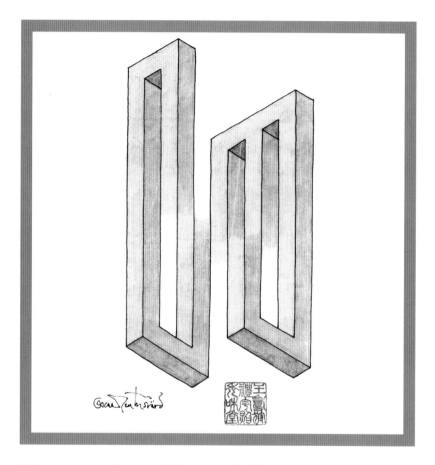

There are several impossibilities in this figure. Can you find them?

Strictly on the Level

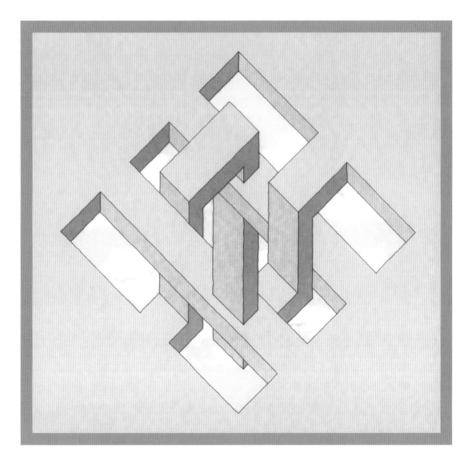

Everything seems to be at the same level, but at the same time they are not at the same level.

Graphing the Impossible

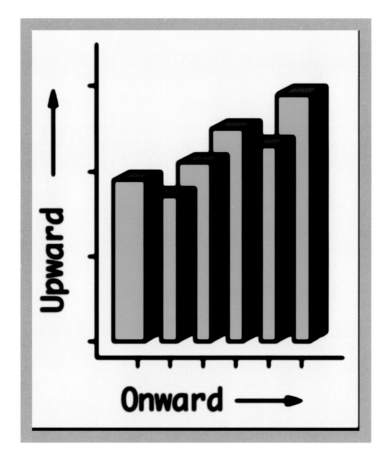

This graph is impossible.

Cartoon Panel I

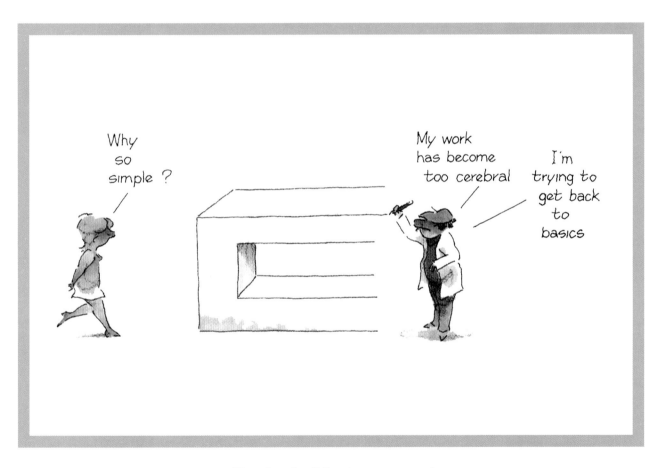

(See also the following two pages.)

Cartoon Panel II

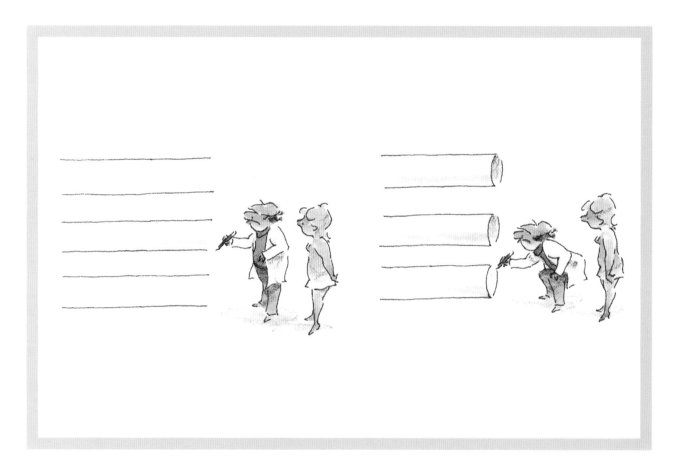

Cartoon Panel III

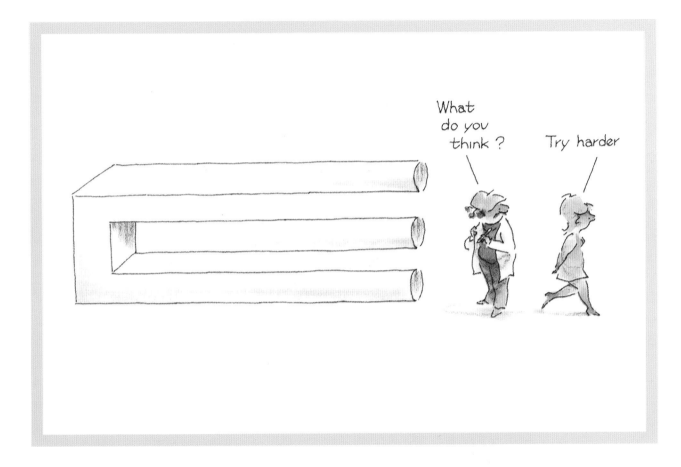

Larger Within Smaller

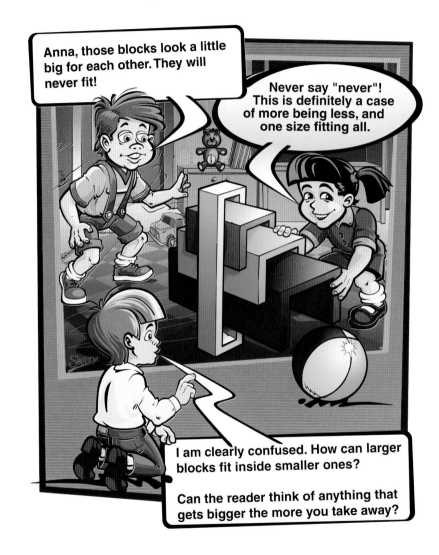

Celtic

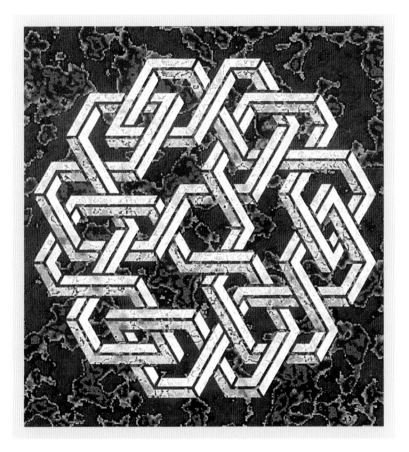

Another impossible meander.

This Isn't Adding Up

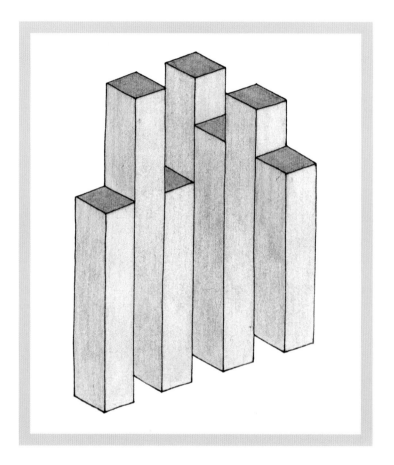

There seem to be more blocks on the top than at the bottom.

A Strange Orientation

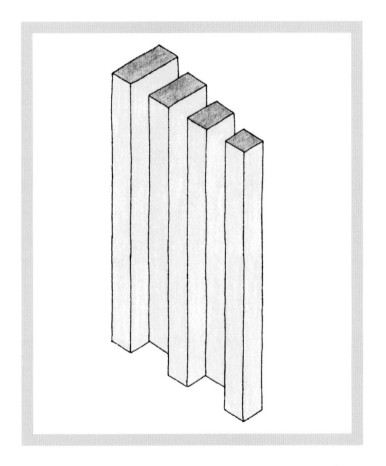

The orientation of the blocks at the top seems to be different from the bottom.

The Garden Fence

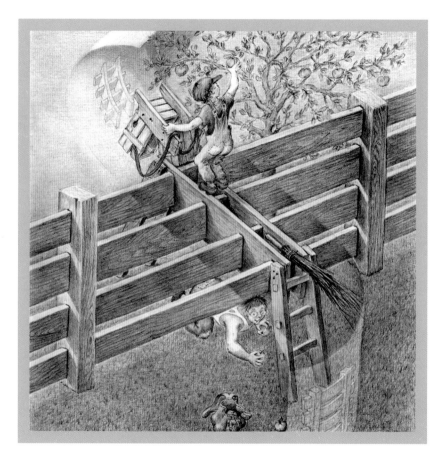

What is wrong with this garden fence?
Try covering either side of the fence.

Belvedere

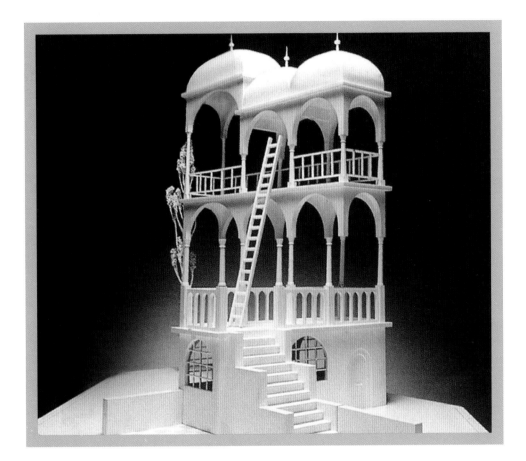

Is the top of this building connected in a funny way to the bottom of the building?

The Solution of Andrus's Box Impossible

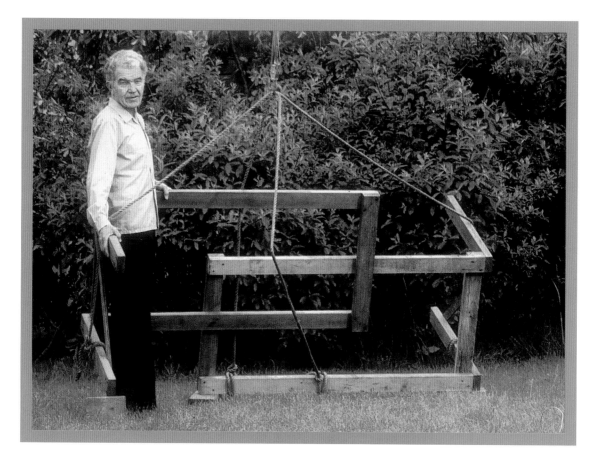

This is the solution of the impossible crate found on page 46.

De Mey's Strange Room

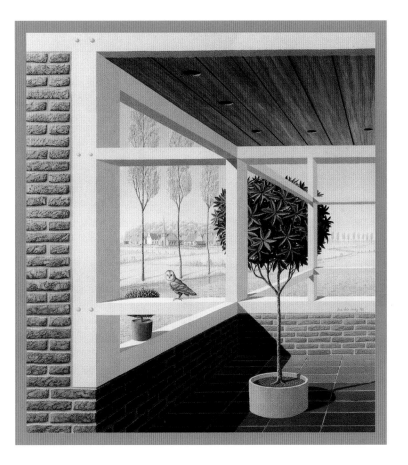

This room has a strange extension.

Rubic

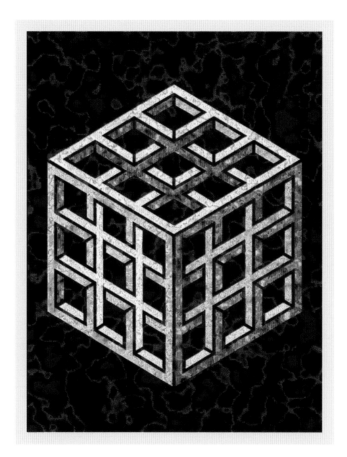

The sides of this cube seem to twist in a paradoxical way.

Legs of Two Different Genders

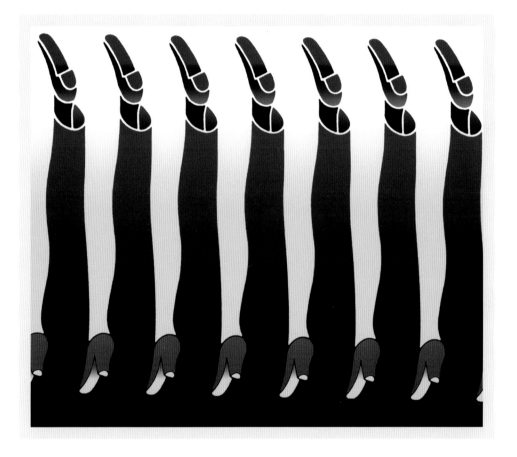

Can you find both male and female legs.

Two Paradoxes

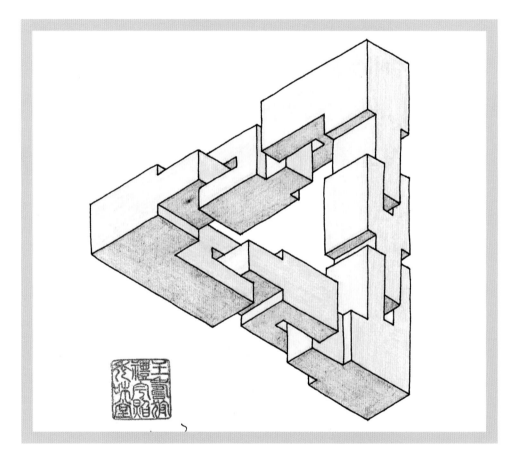

Larger pieces are fitting into smaller pieces in this impossible triangle.

The Direction of a Paradox

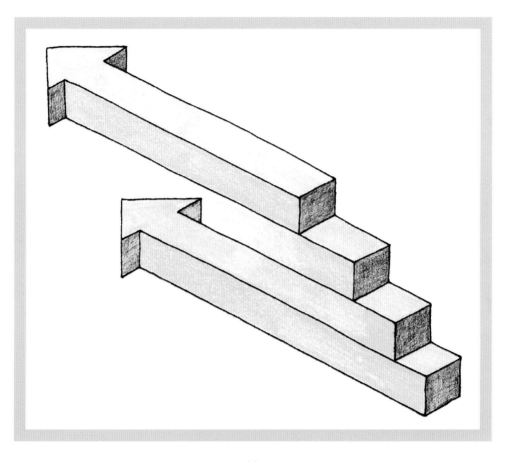

Impossible arrows.

A Building with Some Unusual Twists

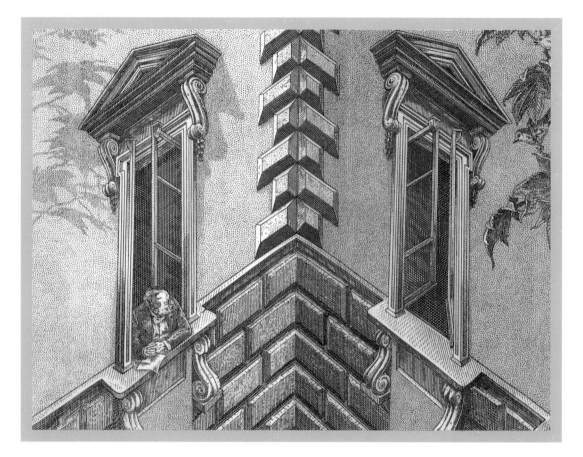

There are some strange things going on with this building. Can you find them all?

Geometrical Ramp

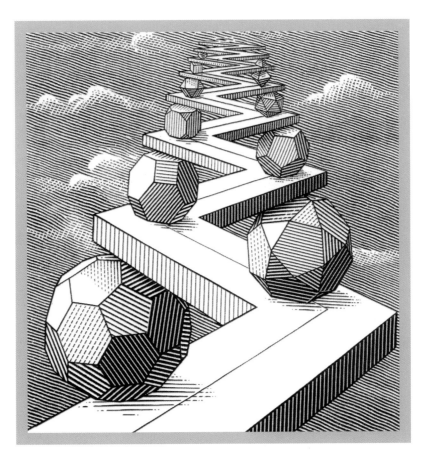

Can this ramp really exist?

Folded Chess Set

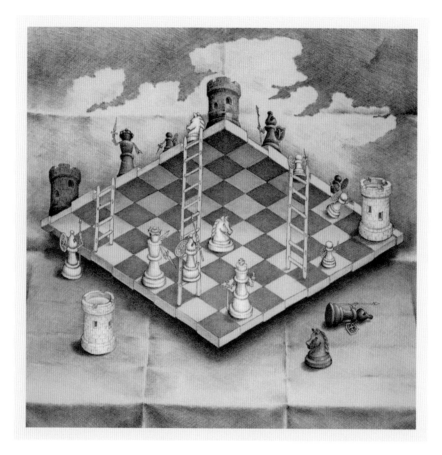

Are you seeing this chess set from the bottom or the top?

Strange Aquaduct

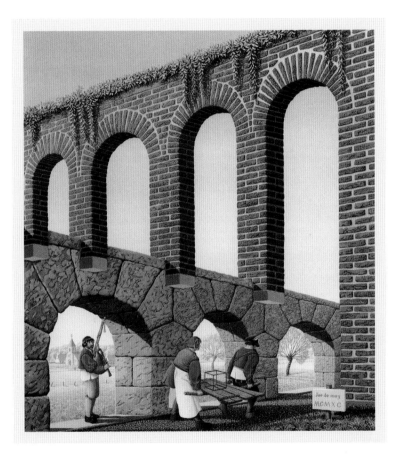

The top of this aquaduct connects to the bottom in an impossible way.

Different Perspectives

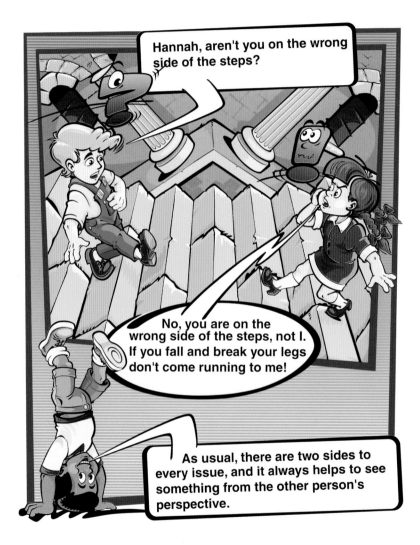

Opus 1

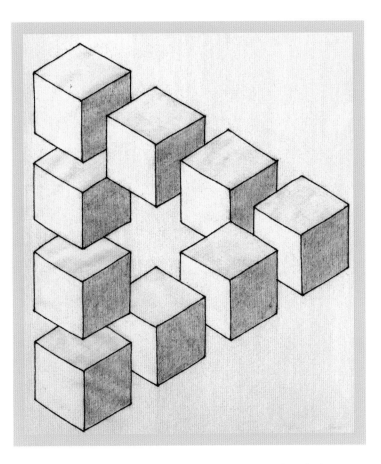

Can you really arrange a set of cubes in this fashion.

Globally Inconsistent

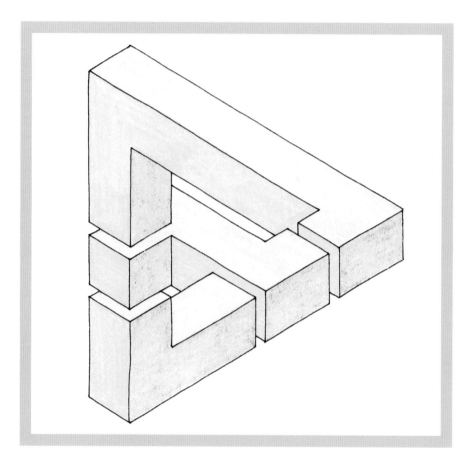

Each piece of this impossible triangle seems possible, but when combined, the triangle itself is quite impossible.

Extending One's Thoughts
About an Impossible Triangle

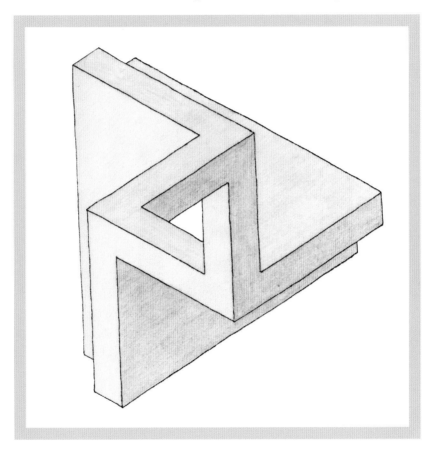

If you extend the impossible triangle, you get this type of impossible figure.

Relativity

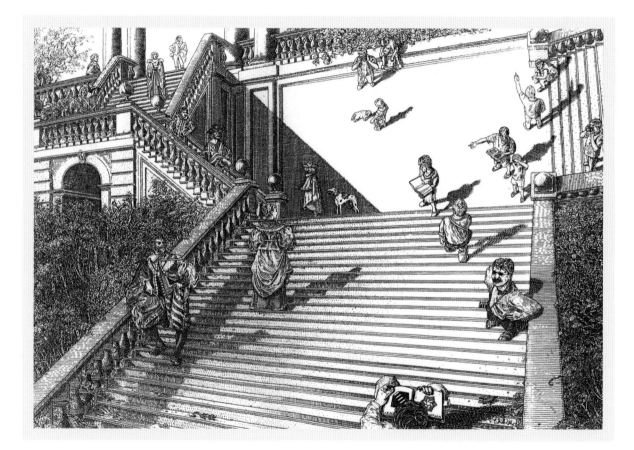

The perspective of this drawing seems to be quite unusual. Why?

Anno's Blocks

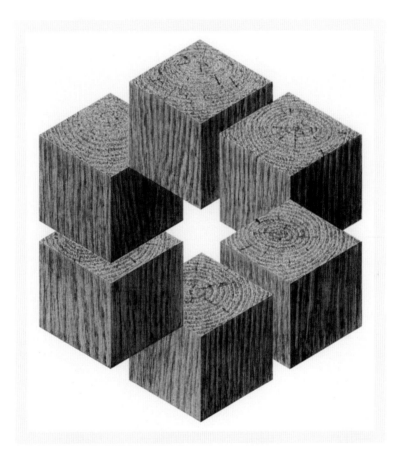

Can you arrange wooden blocks in this way

Moretti's Impossible Ring

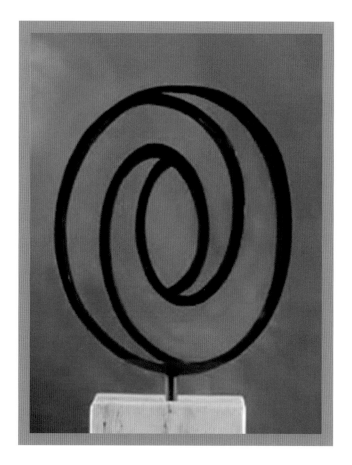

This is a sculpture of an impossible ring.

The Freemish Crate

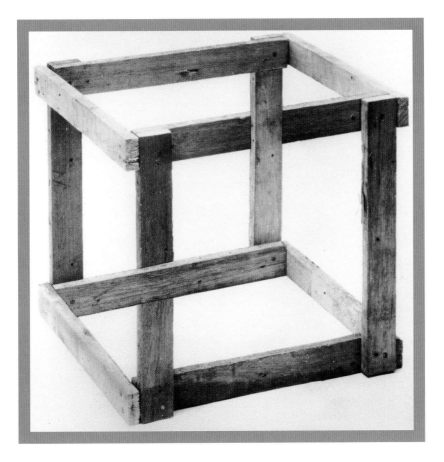

This is another impossible crate.

Bossum's Impossible Rings

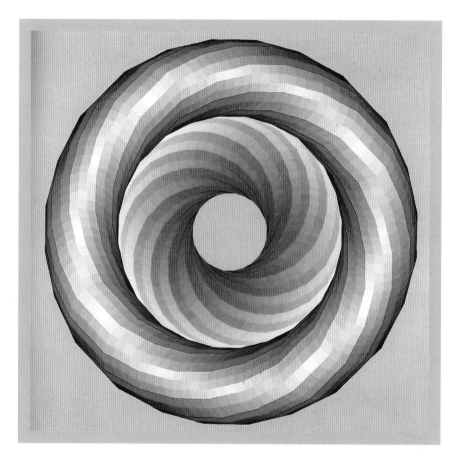

Two sets of impossible doughnuts.

Variations on a Theme by a Hungarian Artist

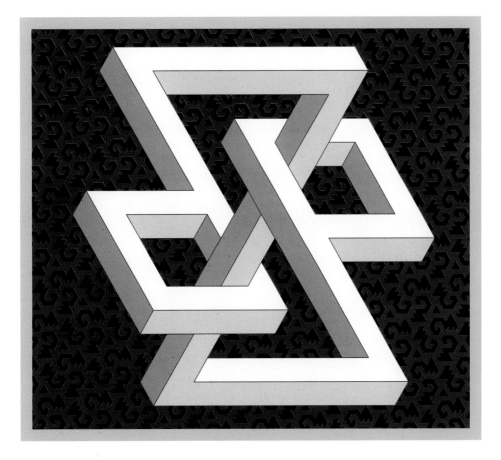

A lovely variation on the impossible triangle.

Thinking about Life's Paradoxes

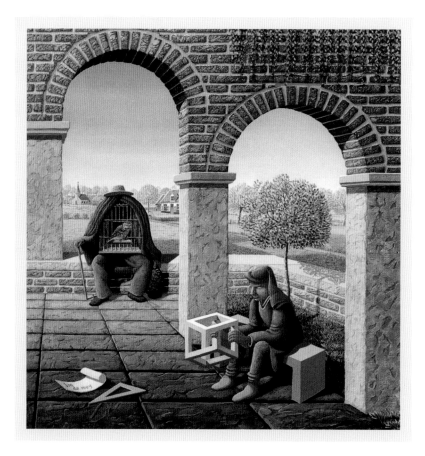

The three columns have contradictory depth relationships.

Fukuda's Strange Twisted Figure

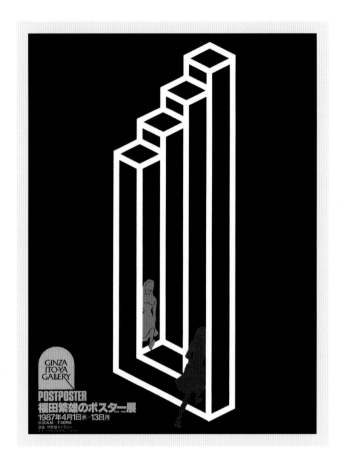

Another strange figure.

Gateway to the Fourth Dimension

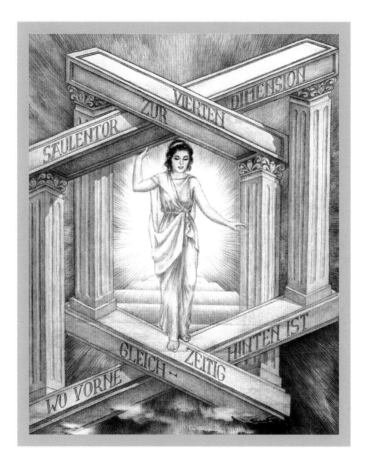

Lots of paradoxes here.

Contemplating an Impossible Cube

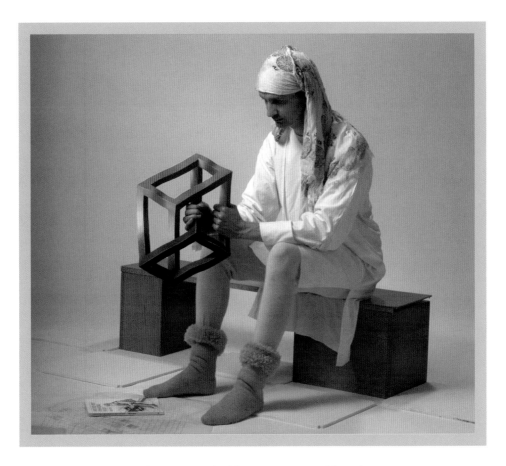

This man is holding an impossible cube.

Junctions with Some Unusual Buildings

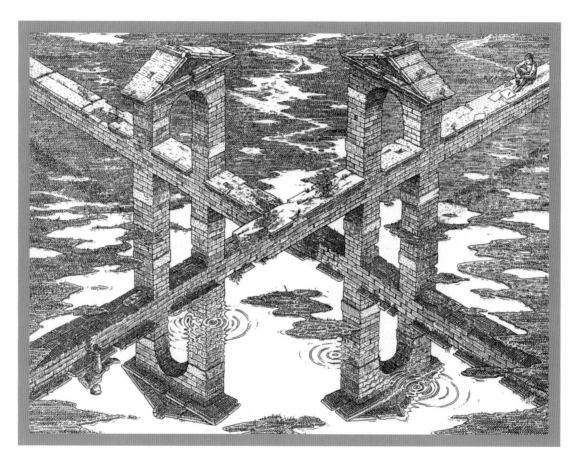

What is wrong with the buildings on top of the roadways?

Packing Problem with Dogs

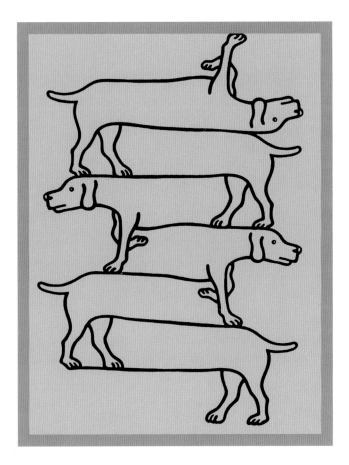

How can this be?

Inverted Impossibility

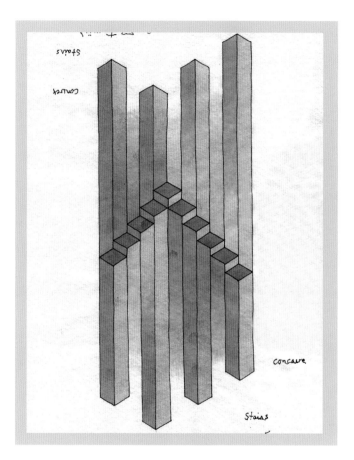

This figure is impossible right side up, and also impossible when you turn it upside down.

The Impossible Triangle

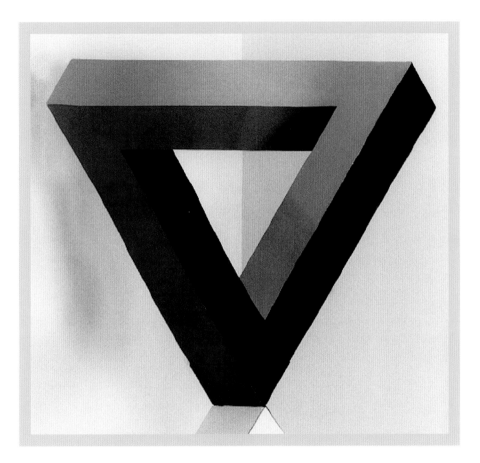

This is a physical model of the impossible triangle.

Moretti's Sculpture of the Thiery Figure

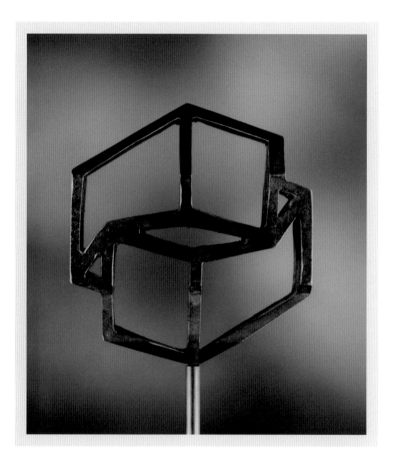

A set of impossible blocks. The middle section can either be seen as the bottom of the top block, or the top of the bottom block.

An Impossible Connection

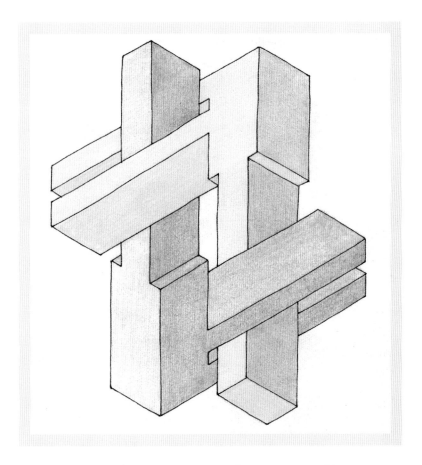

These two figures are connected in an impossible way.

Flip-Flop

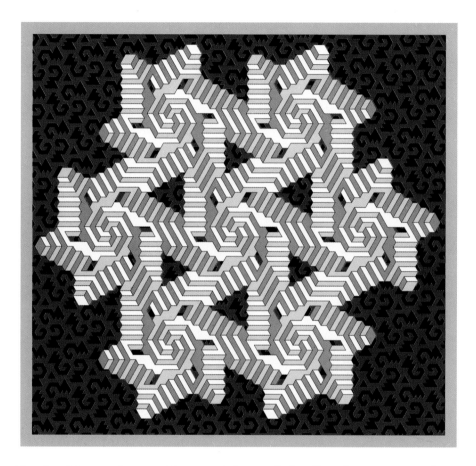

Ponder this set of impossible stairs. They will flip-flop if you stare at them.

Moretti's Impossible Fork

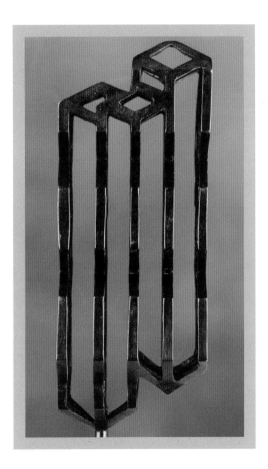

There are three blocks on the top and only two on the bottom in this sculpture.

Simultaneous Directions

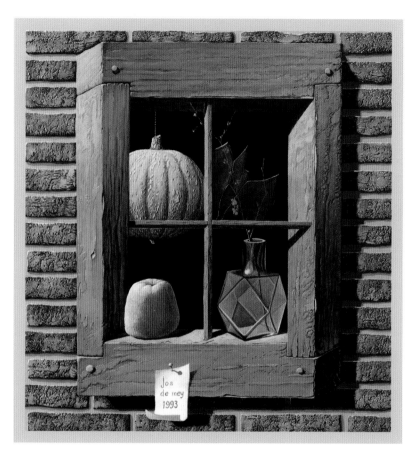

What is impossible about this window sill?

Fukuda's Impossible Columns

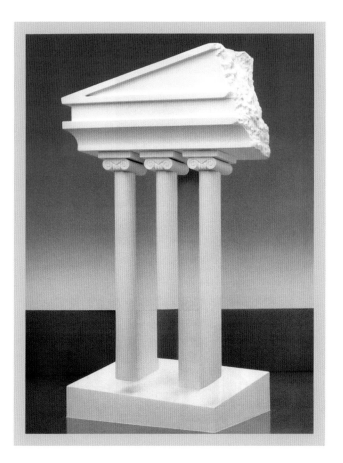

This is a physical model of a set of impossible columns. Cover the top half and you will see two columns on the bottom. Cover the bottom and you will see three cylindrical columns on the top.

Final Thoughts

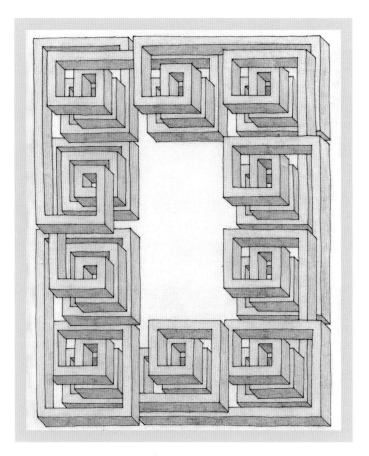

An impossible meander to leave you thinking.

INDEX

ABOUT THE AUTHOR

Al Seckel is the world's leading authority of visual and other types of sensory illusions, and has lectured extensively at the world's most prestigious universities. He has authored several award-winning books and collections of illusions, which explain the science underlying illusions and visual perception.

Please visit his website http://neuro.caltech.edu/~seckel for a listing of all of his books on illusions.